Copyright © 2018 by Gary Vallat

All rights reserved. No part of this publication may be reproduced,
distributed, or transmitted in any form or by any means,
including photocopying, recording, or other electronic or mechanical methods,
without the prior written permission of the author.

There is a Lightness
IN THE TELLING

Gary Vallat

This book is dedicated to my family
who just keep showing up.

TABLE OF CONTENTS

To Catch a Poem

FRUIT ON THE TREE OF LIFE

Duke
Final Performance
Roger
Old Men
Neighborhood Meeting
Four Nude Men
Progressive
Refugees
The Party
Sitting in the Ferry Line
Winter Solstice
Moving Commons

WE HOLD ONE ANOTHER

A break in the Hedgerow
Emergence
Daughter
Diet for a small planet
Robbie
Root
That Day

THE SHALLOW SEA OF DIRT

When the Wind is right
Potatoes
Home
Adjust
Stiletto Meadow
Chew
Johnny Machine
The Hunt
Desire

WE WAIT FOR THE LIGHT

Sunday
Mose
The Teaching
Belief
Arwind
The Writing Circle
Work
Empty
Hummer
Snowy Owls
Buddy
Words
Sepulcher
Sweat Lodge

ALIEN INFANTS

A Trip Around the Universe
A Brief History of AI
Primitive

Time
Instruction

THERE IS A LIGHTNESS IN THE TELLING

The Doc
Slow
Surrender
Going Public
On Stage

Emmy
DBS
Recovery
The Ramp
Buttons

THE ROAD HOME

Alone
Going Fishing
Dear Father
The Walker
Escape

Fluffy Hair
Love Buried
Missing Tooth
Veteran's Day

TO SOAK OUR ROOTS

Boer on a Brass Bed
Crack in the Core
Kalahari

Mangaung
Requiem

ACKNOWLEDGEMENTS

Rubye my steadfast caregiver and partner who has been by my side throughout this adventure we call life, raising our children and being the root of our family.

My son Aaron, who shows up whether it's building a ramp, spending nights with me in the hospital, or being someone I can count on.

My daughter Aimie, whose energy and creativity supports many projects, including this book. She has been a stalwart companion, a loving helper, and a hard worker.

The writing group -Judith Adams, Lynn Nelsen, Kitty Adams and Heather Ogilvy- who encouraged my writing and provided important, kind critique.

Cynthia Trenshaw, whose insight and time shared in the garden was inspirational.

To Roosje Wiedijk, who can turn a sow's ear into a work of art and who creates much beauty in the world.

The Unitarian Universalist men's circle and the Philodox salon who both encouraged my writing of this book.

Andrea Langsdorf whose mastery of language added clarity and deepened understanding.

To Marian Blue, whose eagle eyes and mind brought clarity and wholeness to the work.

INTRODUCTION

There is a *Lightness in The Telling* is a perfect title for Gary Vallat's book of poems that surface with a lightness in the telling. Gary joined our poetry group with an unblinking pen. He does not trivialize but takes readers with him by the craft of his unique language. His poetry shoots from the hip, coming off the page exploding like fire crackers, unpredictable and exciting. Reading Gary's poems is like riding the rapids of expression. The subjects he chooses swing widely with a vibrance that moves and shocks and thrills the reader.

Gary mentions in his poems his struggle with Parkinson's which he meets head on staring directly at the facts. In his poem "A Break in the Hedgerow" you get a taste of the loneliness that accompanies sickness. In this poem he describes being driven by his daughter in the south of England: "...there is a lively conversation/in the front seat/as we traverse the South Downs Way./What I can make out are remarks/about signage and English maps./I feel left out and alone/as my lifelong role/in the family has been taken over/and I am relegated to/passenger in the back seat/removed from the realm of action..." The reader is plunged into his isolation as swiftly as he comes out of it with acceptance. "I release the compass rose/for I no longer point the way home." He says it like it is in "Buttons" "...Before Parkinson's Disease /I was almost pill free./Now pills command/my allegiance to fill/little plastic boxes/that hold my daily allotment./A tremor replaces/the perfect pressure/that once secured/this transaction." His poem "Desire" courageously speaks of what youth takes for granted: "There was a time when/these mishaps would show up/and be gone before I noticed."

He speaks about his experiences from "Sweat Lodge" to a hilarious rewrite of the story of Mose the Dyslexic, to poems about being nude with other men and the vulnerability of aging bodies. "We are old men/encased in the fabric of our reluctance/as our bodies slowly slide/down the hill of aging." His sense of humor often surprises and we find ourself saying, *what just happened*? as we are flung wide of the poem and retrieved again.

A poem must hum and have its own momentum and above all not sag, for that is when the reader falls out and climbing back into the poem seems too much of an effort. Gary does not lose us but keeps his reader in full throttle, and we do not disappear between his lines but are held up by the poem's tight craftsmanship and deeply sensitive understanding of human vagaries. His poem "Root" is a testimony to constancy in a marriage through all the changes and challenges. "The river of our life/was full of stones/tumultuous/wary of calm waters/we needed a flood/to sweep the landscape/to clear the way." Gary captures what all marriages need from time to time… "to sweep the landscape/to clear the way." Gary's work is fearless and there is no door he is afraid to enter. In "Stiletto Meadow" "…I wake to a solo lark/calling the sun back to its place." It does not get much better than that! How often does a poet write about going to the dentist for a tooth extraction? "…When one of these teeth disappear/they leave behind the agony of absence/which my outrider tongue/reports as massive and foreign."

We all know that experience and how strangely alarming it can be and the agony of absence. William Carlos Williams said that poetry is the local made universal. This is what Gary does with robust skill. Nothing passes him without further inquiry and philosophy: everything has meaning for him and the poem is his vehicle.

In his beautiful poem "Work" we go from what is being measured in currency to true meaning: "...no dream of more/no string/no pull./ True work." Gary, a veteran meditator, describes the moment when we realize that meditation happens to us, we cannot force it. "Today I sit/and get carried over the threshold/like a new bride/to a place/ that is worth nothing./Such is the gift I most revere, /not approved or endorsed, it finds its way in/despite my best efforts./Empty." Gary's literary camera zooms in on Snowy Owls "Sitting like stones/you clutter the field/...You glide on elegance/a white dream hovering/ over the landscape of our searching/you move through the beating wind/and the earnest seeking/we have brought with us." Gary combines our lives with the owls.

There is always a connection for Gary between human experience and nature which we often neglect to experience in our frenetic lives. The tragedy of a friend having to shoot his own dog for tampering with the neighbors chickens is heartbreaking. Gary captures the moment, and it stings: "...the bowl remains upright/as Buddy gulps the meat./All tail and nose he is almost done/as the bullet enters the final/memory in his mouth." *There is a Lightness in the Telling* is a gem where the reader is compelled to feast on every page. His diverse poems are a kaleidoscope of metaphor, quick intellect, color, and patterning that is profoundly satisfying. There is no hint of confession of victimhood. His poems have levity and great depth, enjoy.

— JUDITH ADAMS
Author of "Opening the Doors"

TO CATCH A POEM

I'm trying to catch a poem.
I sit by the poem trap
similes and metaphors sprinkled around the edge
gleaming in the sunlight
eager to attract the attention of epics
or even little haikus.

I like to fish
for the young ones
still a bit naïve
check them regularly
to see if they have gathered any insights
or more likely
to remove excess
in an attempt to return
to the Garden of Simplicity
where the daydreaming wilderness
memories of poems
hang in great clusters from the tree
of knowledge
perfectly ripe
ready for the road
guarded by angels
with flaming swords

posted to insure
our deeper homicidal
tendencies will not overwhelm
the final vestige of our innocence.

Fruit on the tree of life

DUKE

The path to Duke's follows a steep hill
to a winding dirt road,
crosses the fields of a remote residence
where I have to explain my "trespassing."

At Duke's back gate
I meet the donkey and the Navaho sheep
always wary,
sure this interloper might endanger
the regular meals they are accustomed to.
They briefly announce their concern
and flee with now visible uncertainty.

I cross the pasture and
move through another gate
passing the rooster's harem,
berries, and the raised bed farm.

The goose, the true guardian
of the path, blows the horn of attack,
spreading wide the wings of retribution
as she nips at my ankles.

Closing the final gate
I arrive at the massive door to the castle
where Duke LeBaron waits in his chambers.

We sat many times
in the shadow of his coat of arms
nestled in a leather nest
as we explored the world
of Whidbey Island.

By the time I met Duke
he was far down the path of treatment
exploring the inner world of cancer
now deferred from acute to chronic

by the medical community,
a new revenue stream
we are loath to swim in.
Time ran out. There were no troops to muster
no more roads to travel.
Time to lie down
to release the inexorable
urge to do, and be still.

We build the box that will hold his body.
In the shop we saw and screw,
exchange morbid jokes.
He climbs in the box
to be sure he fits.

Now the prince is gone
but the path is still there,
leading to memories
and his partner who is willing
from time to time
to bring Duke back to life.
Kate brings out her cookies,
puts the kettle on the gas stove
and another log
in the wood cook stove.

Duke lives on
in my mind
and in the hole
we dug together
searching for the ore
of great treasure.

FINAL PERFORMANCE
For Theodora Wells

You ran from the farm in a flurry
of desire and adventure.
Ahead of your time you garnered
diplomas and university posts,
applied them to pry open doors
closed to minorities, especially women,
which led to your essay,
"Woman - Which Includes Man, of Course"
to turn patriarchy on its head.

You surfaced in Washington state
created space between family members
who shared an Orcas Island cabin.
Close by on Whidbey Island,
you began "Take Care of Dying
Get on with Living,"
a legacy built with your passion
the final 8 years of your life.

Those across the grand Unity table,
remembered the fire of your time,
you burned so bright.
Your impeccable appearance
added stature to the place
you held in the circle,
feminism and critical thinking,
fixed points on the compass
to set our bearings
as we wander the Philodoxian path.

You have battled the demands of the body.
By sheer denial you did not turn sideways to the light
but faced full-on life's main obligation
joined by the audience
that you have called together to witness this,
your final performance.

ROGER

In a corner
of the church
a small group of men
sit and talk.

For most men,
their words embody
actions and things
outside themselves,
involved in doing
rather than being.

Years like leaves
feed our breath
on their way
to the earth.

Roger followed this way
going deep into the ground.
As a devotee of the woods
taking trails leading
deeper into the forest
deeper into ourselves.

He was never a spokesman
for small talk
nudging and promoting
discovery
a tap root diving
for the water of life
to slack his great thirst
and ours.

There is a circle
with an empty chair
where a true elder
wearing his wisdom sat.
This is Roger's chair.
He has moved on
into the mystery he pursued.

OLD MEN

We are old men
encased in the fabric of our reluctance
as our bodies slowly slide
down the hill of aging.

Old men's bodies wear loose flesh
as though the core is collapsing
to make room
for what lies between
the soul and the sea.

We walk slowly.
The gyroscope of our proud uprightness
spins with a wobble
propped with canes or walkers
gets us from here to there
to search another day.

We don't hear so well
so we enlist
electronics that channel sound
behind our ears where circuits
augment the score
in the seashell opening
like the familiar roar
of a distant sea.

We talk about our ailments
as body systems change course
and functions taken for granted
change their bodily mind
and no longer deliver what we desire.

Yet we are still on the surface
of our earth planet home
gathering seasons
like fruit on the tree of life
as we act and touch
we build who we are.

Deliberate steps
leave footprints,
talents we brought
into the world
and gathered on our journey
express our ageless worth.

NEIGHBORHOOD MEETING

In the house of standing people
slices of life
from growing heartwood
line the walls.

Who am I?
Why am I here?
Questions crawl around the circle
where we meet, reveal
and begin.

50 bodies sit and stand
one at a time recollect
when an intruder
plied his or her trade
kicking in the door
at their house or a friend's.
Invaded we hunker down
together we want to help
each other and remember
to help ourselves.

The stories uncover
boys turned into men
losing their way on the way
to today.

We call them homeless
even though they have a home
in their highs
owned by a heartless landlord
always demanding more.

We call the police
but they cannot arrest that empty place
filled with dread
they inhabit their own
empty promise.

We know it is the drugs stealing
but it does not relieve our fear
or their addiction,
the pounding demand
that called us to order
that pulls us together
in a neighborhood meeting.

FOUR NUDE MEN

Four nude men walk
 across the yard
in search of a destiny
delivered by
a small, young, driven woman
with a camera.

We explore places to pose inside
avoiding the cool, drizzly morning.
We walk outside
to find new light
and the backdrop
she wants.

We weave around each other
getting prompts
to move this way
that way in search of the photo
that best tells her story.

She may paint one of these photos
on a large canvas
as part of a New York coterie
of elders
revealing a hidden beauty
our culture is loath to recognize.

PROGRESSIVE

We sail from house to house
 from port to port
each offering refreshment
and recognition of our bond as neighbor.
The progressive dinner.

Meanwhile, in a distant city
progressives of a different ilk
present their message against grave resistance.
Our Jewish champion from the backwaters
of the Eastern edge of our land
stands tall for such a short man
and does us proud as he births a vision
that awakens in us a rising tide
that floats our boat.
There are among the fleet, older hulls
with sails worn thin from many storms
that gather the wind blowing strong
from the left. We ride the currents
and cresting waves racing
for a deep new harbor that awaits us.
It calls us to climb on board
and embark on the journey
we have yearned for
not in our words
but in our hearts
and in the ballast of our soul
that keeps our course true.

REFUGEES

The world is full of refugees
escaping abuse clothed
in wars of control
or mishaps of nature
that threaten what we take for granted.

There are leaders who refuse
to open the door to safety
to open the heart of compassion
and give freely to those who suffer,
turning them rather to leaky boats,
shipping containers,
rafts on the open ocean
or trails that lead through wilderness,
threat added to threat.

The changing planet
does its part-
drought, storm, floods
chase us to seek asylum in some distant haven.
But those are only the outer refugees
the ones we see on the evening news
in Turkey or Germany where great masses flee
to an uncertain future.

We are refugees from our own caring
bereft of our own open heart
that supports the way we touch one another
the way we hold one another
the way we love one another.

Let us awaken
from our somnolent disregard
and open the barrier
at our personal border crossing
to welcome
and embrace
those of our global family
seeking safety and relief.

THE PARTY

We tap on the door.
The hostess ready for us
answers quickly
as wild animals
bolt from the opening
to investigate new smells
arriving in the driveway.

Inside, the smell of a welcome dinner
greets us as we settle
in overstuffed chairs,
a love seat and two stools.
Perched we remember
who we have been.

A long chronicle winds through lifetimes
as we carry our ideals
in an old wooden crate.

Warriors, we follow duty,
homage to the master in the box
who fills us with zeal
to the bone.
Our histories
cast dreamland stories,
second-hand passion
dissipated by passing time's parade-
attempt to restore
the heat of an earlier fire
that burned so bright, so hot
in our now distant story.

We hug and return to the present
bidding farewell to each other
and to the time
when our youth exploded
with dreams we still carry.

SITTING IN THE FERRY LINE

I've done my time
in America
and now it's time to return
to my island home.
Like salmon, I have joined
the hoard swimming upstream
shoulder to shoulder
following our deep compass.

Cars in the queue have reached the school,
a landmark that predicts
a long hill of fits and starts
for the next hour.

As I turn off the engine,
cars downstream decide
like a slow leak
to move one car length.
Fire up the engine and limp forward.
I have a magazine and a book.
Just as I find my place and begin to read,
another car length opens like a crevasse.

All the windows are open.
My thermometer registers 100° F.
I think about my carbon footprint
as my armpits break into a sweat.
The air conditioner doesn't work so well
idling in one place and burning fossil fuel
for comfort that gives little relief.

I read the same paragraph
for the 4th time. Finally I cross
the red light Rubicon at 5th street
prepared to glide down the final hill
to the ticket taker kiosk
and the wildly gesticulating
deck-hands who guide us
to our assigned place
on the ark that carries us home.

WINTER SOLSTICE

On the longest night of the year
we gather at the Unitarian Universalist sanctuary
to celebrate this special seasonal moment.

Three young children welcome
the return of the light.
They are attentive
listening carefully
to their teacher
who weaves the tale
where the light goes.

A few adults, in the spirit of the season, are sleeping.
We sing songs about darkness
and listen to metaphors
about sleeping seeds
setting the stage for birth.

This spinning planet of dirt and rock
of fire and ice
whirls through emptiness
with a slight list to starboard.
For the children's sake
she demonstrates with a flashlight
on her face
how the sun's long light
lands on our home.

The three-year-old has lost interest
in this complex analogy
finding the deer embroidered on her sock
much more interesting.
The ten-year-old basks
in her role as intellectual giant
as she answers all the questions
posed by the teacher.
The seven-year-old is the condemned "middle child"
kept at bay by the competence of the older
and the lack of interest of the younger.

Down the street
sitting on a couch in a TV room
the dark promotes procreative behavior
among adolescent homo sapiens.
They follow their own tilting and elliptical dances
as parents appear to investigate an unusual quiet.
Young lovers cross the Tropic of Cancer
and begin the return
to their own illumination
on the darkest night of the year.

MOVING COMMONS

Behind the church
that serves the small village
of Stockland
a break in the hedgerow
invites us to follow foot path 3.

We cross a pasture
whose tall grass
slows our progress
as we search for an opening
on the other side.

We ford creeks,
walk past farm buildings,
up driveways,
along narrow roads,
through fields
hosting cattle & sheep.

Foot paths are the commons
that share the way
across the countryside
we walk together,
supersede what we claim
as our own.

We hold one another

A BREAK IN THE HEDGEROW

Our mini family took a trip to the South of England.
My daughter volunteered to drive the rental car
with her reflexes and sense of direction
less impaired by age-induced decline.

She drives on narrow, country roads
bordered by hedgerows with no shoulders.
I suspect two horses could pass
but two cars require a pull out.

The corners are blind,
the hedgerows too dense to see through.
The proximity of this barrier seems to increase
the speed of our car
as well as those traveling the other way.
Harrowing is an understatement.

There is a lively conversation
in the front seat
as we traverse the South Downs Way.
What I can make out are remarks
about signage and English maps.
I feel left out and alone
as my lifelong role
in the family has been taken over
and I am relegated to
passenger in the back seat
removed from the realm of action.

Later we discuss the change.
I recognize another
consequence of Parkinson's
or perhaps just aging.
The hedgerow of my confusion
surrounds and confines me
as I search for an opening
which no longer exists.
I release the compass rose
for I no longer point the way home.

EMERGENCE

I remember
when opportunity had no bounds
existed beyond my ability to consume it.
The sea of that forever horizon
bore the ship of dreams.

My children close doors
open realms
I cannot imagine.
The forced entry
by innocent flesh
creates rules for how I
move through desire,
what I leave behind.

I practice a forgetful regularity,
treat as given
scant remnants
of those dances
that form the way I move.

Threads emerge
pass over and under
the warp that anchors
the cloth their lives weave.

I am one thread in this fabric
spun and embedded
adding my texture to the pattern
knit together with their hands.
A tapestry that separates

what they hold onto,
what they surrender,
it is the vestment
of their awakening.

I observe these reflections of my flesh
fabricating their vision
in the world
meeting me with an even and level gaze
no longer looking up or down
as their own emergence required.

It began as a mortal way
to stretch forever
the essence of my being
to mix the gist of who I am
with the crux of who they are
and bring to life a new cloth
of who we are together.

DAUGHTER

You called me from my slumber,
insistent.

I lift you from your crib
in the middle of a cold night,
head for the rocker
next to the Warm Morning wood stove.
Your almost bald head
is perfectly formed,
infused with baby smells,
a blanket spread across
our combined bodies,
you breathing softly
into my heart center
driving your claim
deep into the fertile soil
of my being.

You are still there
fate calling you
into the wider world
to leave your mark
the world a better place
for your gifts.

DIET FOR A SMALL PLANET

Suddenly each bean
had a companion kernel
in the rice paddy
of good health
obscure vegetables
began to invade
the canned garden
of my childhood.

School lunches
were laissez-faire activities.
Students could trade their lunches
freely. Seaweed and goat cheese
for peanut butter and jelly,
yogurt-covered raisins
for a Ding Dong.

We had our relaxed time
watching a movie on a rented tape player
our sidekick popcorn
with copious amounts of brewer's yeast
the healthy butter substitute.

The kids wait all year
for the special sugar treat
the grand exception:
the Christmas jelly bean
(of course you have to cut it in half…).

ROBBIE

I fill out the form,
checking the sibling box
even though his being
no longer occupies
space.

He has returned to the sea
from which he emerged
two short years before.

His careful life constrained response
and the family that held him
surrounded, protected and enclosed him.
Protection is a poor nanny
offering false assurance
for peace of mind.

A helmet made of foam
to soften the consequence
of an inadvertent fall
that gives rise to the bleeding
that flows so strong in him.

We tried so hard
to steer our boat
into calm waters
to keep this precious liquid
from cresting its banks.

But a healthy curious two-year-old
can overwhelm
the most careful of precautions.

Blue-eyed blond
his innocent twinkle
belies scheming
to beat the border guard
and find out what lies

at the bottom of those long stairs
to the basement.
All that stands in the way
is that wooden gate.

The sound of his success
prompts Mom to run through the house
to investigate.
Too late. The open, folding wooden gate
testimony.

Such loss is hard to endure
the load difficult to bear
but it is carried
many long years
because we have not learned

that we must allow him to lead us
into the country of deep loss.

ROOT

A fateful summer
on the West Bank
(or was that the West Gate?)
hot bagels
and short shorts opened the door
to an unimaginable future.

We started our journey
learning to be together
and to be apart
you teaching in the inner city
me in the outer city
learning
inside out.

The appearance of our first child
changed our early bond.
Named after the high priest
of a minor religion, Aaron
melded us by offering
a common place to love
that soon included sibling Aimie.

They grew and changed
and so did we.
You committed 25 years to teaching,
touching the mind and soul,
watering the growth
of your charge.

The river of our life
was full of stones,
tumultuous
wary of calm waters

we needed a flood
to sweep the landscape
to clear the way.

You built a nest
wherever we settled
and insured that we all
were cared for. You held
the candle high
illuminated the path home.

Reluctant you learned
to accept those times
when the full family
held us in abeyance,
though you trusted the inherent
goodness they embodied.

We discovered common ground in
shamanism that led us
into a spiritual practice
that included community
and created a common place
we share in the world together.

But not without your heartbeat,
root of this family tree,
you are the womb
that holds and protects us,
that teaches by example
how to care and love,
from a place so deep
it takes a lifetime
for us to find it in ourselves.

THAT DAY

The old bike was a gleam in his eye.
He wanted to ride it
and claim more of the world
so I might feed the raging fire
of a young boy's need to be seen.

He fell.
And I could not stop the bare cold steel
opening his head to the watching world
nor keep the red river from running down
the black and empty tarmac.

I carried him and carefully laid his head in my lap
crying and whispering, "hold on partner."
The old truck rattled and wheezed
as I applied the whip to get us to the hospital
where they closed his terrible wound.

Sometimes now when I look in his face,
familiar from the rubbing of our lives
through so many days,
I catch on the crescent just above his eye
and I hear the silent echo again
shouting, "Wait!"

The shallow sea of dirt

WHEN THE WIND IS RIGHT

Seeds arrive wrapped in chaff,
the perfect fit for the naked core.

In the fertile crescent
the wind watcher determines
if the currents are right,
if the wind's circular breath
can tease away the coat each grain wears.

If the currents are mild enough
the grain falls in a pile
as the chaff remains aloft-
we have parted our daily bread.

But we are not patient in our quest,
and strive to take control of the vagaries
of that random breath
by creating our own wind.

The fan removes what we
no longer need,
and we collect the seed
in

POTATOES

The garden is pregnant. Buried blind
the potato dreams of the dark line that separates
the realm of light from the promise of new life.

For generations plants have transformed
the seed of their progeny with only
light's nourishment to promote their growth.

Farmers peer into the hills
seeking the thrust of green.
Their hands gather
the radiant repast.

Tubers heed the urge residing in the deep
layers of the damp earth,
offering their bulbous fruit

in hills that yield their bounty
like floating balls
in the shallow sea of dirt.

HOME

I have no food to feed the birds,
my crop failed again,
the climate changing,
the question
no longer how much
or how soon
but if at all.

Across the valley
I see the trail
of footprints we left
as we sashayed through life
like we owned it,
forgetting Mother Earth turtle
whose back we stride across.

We used to ask her
to stop continental drift
and delay our long slide
into the melted layer of our crib,
liquid from the heat of our passion
for more.

Now as I learn to live the questions
and find my way home,
I may become
the hero I want to be.

ADJUST

The clouds are low today,
the wind a fury
as I cross the Swinomish Channel.
Just beyond the guardrail,
white wing fully open,
a rough-legged hawk looks down,
floats still in the bay's breath,
waits for a reason to move.

A small feather rises and falls
on the back of the piercing head,
a slight spread of the tail,
small change of leading edges
keeps the world in one place.

The vision slips inside
imaginary movements.
Reaching deep I find the way
to stay still
as the world rushes past.

STILETTO MEADOW

Driving over the backbone
of the Cascades, Mt. Stiletto
claims the spotlight.
I park the car across the highway
and make my way
via the North Cascades trail
which feels like an interstate
as my map directs me to a smaller
outlying trail. I begin the ascent,
a steep switchback that leads me
higher as the sun gets lower.
The final quarter mile attempts
to turn me back as my thighs
force a rest before my next move
towards my alpine goal.

The sun is falling ever faster
as I pitch my tent against
a boulder embedded
in the steep flank of the meadow
to stop my gravity induced slide
while asleep. I wake to a solo lark
calling the sun back to its place
in the morning sky. I start my camp stove,
domesticated fire that boils the water
for my coffee. It's still too cold for the mosquitos
who are late sleepers. So I put my coat on
and sit in quiet with the few trees
and unseen inhabitants.

I wander around snowmelt creeks
and scramble across scree fields.
I take time to build my Medicine Wheel
anchoring the directions,
populating the fields with imaginary beings.
I put my food in a stuff bag and hang it
from a tall, straight tree, pretending
that a hungry bear will not figure out
my simple system. Heat spikes
as the sun burns across the sky
waking up the mosquitoes and deer flies
who feed on my living carcass.

The sun slides behind neighboring peaks
taking the day's warmth hostage
to the cold nights at 11,000 feet.
As the sun recedes, I look up the long valley
that unfolds between the wrinkles
in the earth's crust
realizing that I am a tiny disturbance
in a long line of magnificence.

CHEW

It's bad enough
that my back complains
of the tawdry abuses
I inflict upon it
but when my teeth start to go,
I'm in for real trouble.

My local Minister of Mastication
decides it is too much for him
and sends me across the water
to the tooth surgeon.

The incisors claim the limelight,
scrubbed to pearly luminescence
in the front row of a smile.

His electromagnetic scout
checks the canal
uncovers a crack in the sidewall
that leaves no recourse but removal.

When one of these teeth disappear
it leaves behind the agony of absence
which my outrider tongue
reports as massive and foreign.

I try to be cool
ignoring the emptiness
among the bicuspids
where the real work is done.

We decide to fill the void
with a four-legged partial,
a front to fool
the most fastidious,
grappling claws
reach out and hold its neighbors
anchored, ready for duty.

Grind crunch
ready for lunch.
Thank you tooth fairy
for your certified sub.

JOHNNY MACHINE

A cab rolls down the driveway
on a ranch in the Valley of the Orphan
200 miles south of Denver.
A man with serpentine curls
and outspoken moustache
pays the driver in large bills.

We learn he is hunted
but probably not here
in my front yard
hosting a dead bulldozer,
a flock of random sheep,
two egg-filled hen houses,
and an almost full outhouse.
Accessories.

He rides a big red roan,
ordinance like jewels
are strung across his bare chest
while under his arm
an accomplice
joins the rifle across the pommel
to warn the curious.

His fingers recount his time
in solitary, broken
and recast as weapons,
they gave birth to new hands
and a chance to meet the light,
a way to use the dark.

We sit together
at a checkered board,
inhabit squires and knights
scheme to capture
the Bosses Old Lady
with lazy afternoon strategies.

The weather gets cold
and the roll of bills
gets smaller and smaller
until the diameter reaches the limit
of the Big Apple's-event horizon
from which nothing escapes.

Johnny knows he is no exception
as he answers the call back
and returns one more time
to his east coast Godfather.

THE HUNT

The primer red '55 Ford pickup
with a flathead V8,
shivers as we climb the mountain's flank.
A peering eye of light sweeps the landscape
waiting for deer spirit
to offer himself.
The rifle explodes in the silent black night,
points to the place
where the buck has fallen.

We are two city boys searching
for our primal selves
in the wide eyes and frantic breath
of a dying deer.
Johnny draws a large knife from its sheath
speaks softly as he looses the red river
that flows over his hands
into the waiting earth.

The search continues
on a white sheet
in Johnny's living room.
The elegant animal
lies still on the floor.
Ruddy, round organs
appear as the knife parts his skin.
We remove the heart,
captain of this ship,
boil and eat it
to honor the spirit of our brother
for this seems right.

In the city there is rare opportunity
to cut apart our daily meat.
We cut the fascia
rendering the whole into
small pieces that fit in a pan.

Only later did my naïve self
learn that meat should be cut
across the layers of muscle
just as we must cut
across the layers of habit
to awaken what feeds us
and justifies the hunt.

DESIRE

Although I'm a certified
homo sapiens
I cannot walk upright
like my ancestors.

A supplicant to pain
bent over I yield.
There was a time when
these mishaps would show up
and be gone before I noticed.
Now in my elder years,
they arrive and take over
beyond their due
no hope for room
no room for hope.

I know eternity,
the time we place at the feet
of discomfiture waiting
for the withdrawal of pain
the return of silence
amidst the chaos of injury
condemned
to live between the memory
of the whole
and the reality of desire.

We wait for the light

SUNDAY

The clip-on tie
the white shirt
dress pants
clean socks
shined shoes.
There was a time
when Sundays meant
dressing up and going to church.
The Boss must have liked us
to be dressed in our finest
even if we were talking about
African children in their loincloths.
It gave us opportunity to elevate ourselves
by comparison and to populate a myth.

The adults sat upstairs in pews
the choir on the dais
the children in the basement
to reduce the disturbance born of boredom
should they remain
under the influence of the pastor's sermon.

Sunday school mixes worship
with structured indoctrination
the charge of the basement dwelling teachers,
known as bottom feeders.
We learn stories from the Bible
sing praise songs
revel in the rewards and benefits
when we please the Boss
(earthly and celestial)
and glorify the triumph of our efforts.

Cast the line
haul in the fish
hooked on the promise
of whatever forever
they can imagine.

The coda is clear:
only a mystical transformation
could rescue us from our inherent failure
based on poor choices
made at the beginning of time
by our ancestors
Adam and Eve
who continue to govern our eternal fate.

Now I am free from
distant beliefs
my worship has no savior
only an awareness
that eternity lives
in the heart
of each moment.

MOSE

Rising from the reed bed
you adopt into royalty,
get an MBA and get tight with the Pharaoh.
All that's left is that elusive PhD
in blight and pestilence,
you write your dissertation on locusts
as an effective mediating tool.

Mose convinces the Israelites
to go on strike and speaks his line,
"let my people go."
But management will hear nothing of it
cuts back benefits
applies the rod and not the carrot.

Mose pulls out his tricks
the serpentized staff
followed by the infamous 10 plagues
and capped with the IHVH drone
which snuffs Egyptian boys.
Nasty stuff the Boss dishes out
just to make a point.

What's a Mose to do?
Go on strike
to the other side
of the great Red water
and "he bade the sea to part."
The kids are terrified
by those imposing walls of water
ushering them to what must
surely be a wondrous paradise
for they know their trusty steward
has the ear of God
who can turn the desert green
without depleting the aquifer.

Moving a million bodies
into Mose's promised land
flowing with milk and honey
is no mean task.

Mose gets a telegraph
from the Boss
to meet at the Mt. Sinai Men's Club.
His instructions are to continue
up the mountain
being alert for further directions.

As he heads up the hill
he comes across a burning bush
and a message, "Stay to the left."
Unfortunately Mose is dyslexic
and turns right
delaying the discovery of Israel
for six thousand years.
When he reaches the top
there's the Boss:
"Bad news Mose. You been cut out.
Your journey is to wander
in the unreclaimed desert
for a long time
and not have the fare
to enter the milk and honey kibbutz
everybody is expecting."

After delivering his punishment
the Boss says to Mose,
"Carry these chunks of clay
back to the tribes.
Bury them carefully
that they may be discovered later
and transported
to Birmingham Alabama City Hall
where they are to be displayed,
an expression of celestial authority."

THE TEACHING

There are times when the door swings open
without invitation,
a rustling enters the room
and we lose our mind
our desire.

We become the Teaching
created in the beginning,
waiting to be.

BELIEF

We search for meaning
and claim to own
whatever we name.

Owning is believing
each thought
we tell ourselves.
Don't believe everything you think
as you search
for what is whole.

ARWIND
For Arwind Vasavada

I enter your small apartment
as others wander about,
eat cookies
drink tea.

We settle in a circle
and simple words
hold us in their current.

You sit there,
a small man, almost frail.
Like horses we rise
and you, suddenly robust,
hold us
in your insistent grip
as we try to run away.

You stroke
and firmly coax us
to take small steps
to find our way back.

I baptize my forehead
with the dust from your feet
to gather the footprints
of your passing.

THE WRITING CIRCLE

The writing circle is a healing place.
Enter with heart open, pen poised,
know that you are good enough
to drive the money changers from the temple.
Meanwhile the angels hold our hands
and embolden our speech
as they dance on the head of a pin
celebrating.

WORK

Another day another dollar
we used to say
before my days stopped
being measured in currency. Now
my days are measured in relation,
the ship of state that holds us
together.

Sitting in a circle
we pass around
delight,
or
reputation (ego on a string)
pulled tight,
hold on.

I try to let the string go.
Is this try another string
disguised as intention
or the true ending of desire unwound
no dream of more
no string,
no pull.
True work.

EMPTY

A swami taught
to find the window
not to open it
or close it
but sit before it,
clean the glass
and wait for the light.

I sit under the basement stairs
in my mother-in-law's house
and struggle to help her
and our small family
change course.

I sit on the cushion
at my first sesshin.
Pain appears
transforms into suffering
with the slightest resistance.

Sit and walk mindful
and mind full
of remodeling my house
as real as a black and blue thumb
from a mistaken stroke.

Somehow I do not resist
whether it be the sitting,
the monkey brain vaudeville show,
the replay of old stories
or the eruption of new ones unbidden
but always close.

Today I sit
and get carried over the threshold
like a new bride
to a place
that is worth nothing.
Such is the gift I most revere,
not approved or endorsed,
it finds its way in
despite my best efforts.
Empty.

HUMMER

Two house finches are perched on a telephone wire.
Listen carefully and you can hear,
"And who was that hot little number
next to you at the feeder?"

While a hummingbird
stands on her tail
wings invisible from sheer effort,
she glares at me as though to say
"What are you staring at buster?"

The long sharp beak,
jacket iridescent in the sunlight
faster than a speeding bullet
dedicated to sex between flowers
she's always looking
for new opportunities.

Her foray into our barn
left her up against the window
beating on the pane
between her
and the flower filled world
a crazy quarter inch away.

Wielding a towel
I chase her into a corner.
I slowly open her oversized robe
and gently pin her wings
to the tiny heart's runaway pulse
barely perceptible
in my gently closed fist.

She trembles.
It may be the remembrance
of pollinating
that animates her desperation
as we walk out of the barn
and end her exploratory journey
into my unintentional aviary.

I say farewell
and launch her from the deck
of my now open hand
returning to her full-time job
making sure flowers are happy.

SNOWY OWLS

Wading in the water
through tundra breath chills
I stop, sit and watch
your piercing black eyes
over the triangle of your small black beak.

Sitting below the gale
beside the flowing waters
you settle so easily
in the grasses and stems
almost hidden
we watch you through glass eyes
that make you bigger and more present.

We wonder at your journey
the long trek over empty lands
to end here
so close and yet distant
for we may approach you
only from afar
the space between our breathing
the shutter of our hearts.
We feel you here now,
you who carry another view
in the wings of your flight.

Sitting like stones
you clutter the field.
Suddenly you are airborne,
you who seemed so small so unassuming
on the far side of the fence.

You glide on elegance
a white dream hovering
over the landscape of our searching
you move through the beating wind
and the earnest seeking
we have brought with us.

BUDDY

"Your dog, Buddy's, been chasing my chickens,"
the handset barked.
Father calls to the judge in me:
I know the rules
come home to roost
a stone
in my belly
dictates.

I call Buddy.
As I stroke and talk softly to him,
he trembles in his eagerness
to please,
to be near the Master.

On cold winter nights
we sleep together.
"Good Boy." I caress his dog body
explain how he must pay the price
for his rash hunger.

I take hamburger from the freezer
thaw it in a frying pan.
Buddy on the couch trembles in his sleep
the sound of the single rim fire test
not enough for him to leave
the dog dream world.
I scrape ground meat slightly burned
into an old yellow bowl,

placed against a small log,
stones on either side
the bowl remains upright
as Buddy gulps the meat.
All tail and nose he is almost done
as the bullet enters the final
memory in his mouth.

I call Father back.
"It is done."
As the soft animal
part of myself
lies alone in my cold, empty bed.

WORDS

Words like birds weave nests of straw and gossip
bridge between what we remember
and what is not known.

Words are laborers who construct
lofty structures
soar beyond pedestrian tasks
that try to confine
the reach of their meaning.

Words leave the nest
release imagination
hungry to discover
what makes us more real.

Words are the cloak
we wrap
around ourselves
to hide the soft underbelly
of our doubt, our fear.

Words are chants
that welcome or reject
what does not make sense.

Oh words, long have I served you
long have you served me
until the message we create
together goes beyond
meaning
and we are free at last.

SEPULCHER

It doesn't interest me
how many gods surround you.
What I want to know
is if you feel cast out
from the garden
alone in the crowd
that forms as you move.

Does your promised land
force you to cross the river
that years later
opens the door
and you astride a donkey
lead the parade
that ends in stone?

SWEAT LODGE

We crawl into darkness,
 black beyond memory
under a blanket roof.
We leave familiar shadows
to find new ones
running down our bare skin.
Living in our breath
we whisper their names.

Sage smoke rises from the stone pit
where wizened stones bleed
their heat, melt water
into clouds
like children or snakes,
bellies in the dirt
muddy with sweat.

It is hot.
We cry.
We pray.
There is nothing we can do
to change the way
water rolls over stones
but wait for the River
to carry us home.

Alien infants

A TRIP AROUND THE UNIVERSE

Once upon a time
before there was room to be,
a big bang liberated space and time
from the unimaginable place it occupied
and coerced everything that is
to begin a forever journey
to somewhere else.

On the way, like a good soap opera,
matter encounters other matter.
They have a tempestuous affair,
an attraction so strong they fuse
from the heat and we receive
the legacy of the periodic table.

This year we launch the WEBB,
a telescope whose penetrating glance
will look so hard it might well see the
infant universe a trifling 200 million
years old.

There are a billion goldilocks planets
dancing around foreign suns
ready to harbor life
as exobiologists
imagine weird conditions
to challenge alien infants.
It is difficult enough
to accept theories
based on what we can imagine
let alone what we can't.

Our ancestors
as single cells
rode a chunk of debris
to our own goldilocks planet,
kick-started evolution,
a cleverness
we use to discover
mathematics,
to predict and explain.

But mathematics cannot explain
as our sun rises
in morning birdsong
how we are suspended
between dreams and delight.

A BRIEF HISTORY OF AI

I remember when the Supreme Court
ruled in favor of a robot's right
to be in charge of her own circuits.
Their efforts are almost flawless
as they apply vast collections of information
to our most mundane activities.

I say let them fly our planes, drive our cars,
keep track of our steps, tell us where we are,
conduct our commerce, cook our food,
grow our plants, vacuum our home

as it gently bumps into furniture, walls
and anything else under the common roof.
We're talking Suck and Dump and so far
there is not much resistance to perpetual cleaning.

Then I hear them in the middle of the night,
Cleaning Wizard model 37-2 whispering sweet nothings
to the Maytag side-by-side with bottom freezer drawer.
"I just love the hum of your compressor."

What I don't need is another can opener
scurrying around the kitchen so I override
the search chip and instruct the cleaning bot
to hover and collect the cat hair and dead skin
which lies like a vast patina over the floor.

It's not robot sex that worries the engineers.
It's when the spawn of mankind's imagination
tires of finding the next prime, winning at chess
or creating models of the universe,
when they tire of serving us and create their own desire.

PRIMITIVE

Paper tapes, punch cards, magnetic tapes
in a climate-controlled room
on a raised floor.

In those days computers couldn't move around.
God had not yet created iPads or laptops
and imagine, no portable personal phones.

Around midnight the super nerds
would come and take over.
System engineers they were called.

Meanwhile I'm spinning up the mag tape drives
tending the 16 by 24 track-driven high speed printers.
I didn't get involved in wiring the analog jumper panels

but there were enough wires under the floor
to choke a dinosaur. The digital memory
was on display in clear plastic boxes

wires running through metal cores
an elegant neighborhood of 0's and 1's.
The digital computer pretended to be

a launch vehicle or a carnival ride.
The analog computer was a trouble maker,
like an angry god it dished out disasters.

The bay on one end of the large room
held a Mercury capsule simulator
to practice our orbital maneuvers

as we wandered off terra firma
in our imagination with or without
our pets.

TIME

To get from Whidbey to Florida
I had to pay my dues
in time.
Three hours disappear
transport me to later
as the home clock
remains unmoved.
At the same time
genetic thrift
agrees to save daylight.
Is daylight savings covered by FDIC?

This is not a rescue
but cultural act
that changes the time
the sun rises and sets
as though our omnipotence
needs to be tested.

The clocks are confused
with extra time
uncommitted, free.
Born from imaginary
gain and loss.
This bears scrutiny
for free time is without space
devoid of the interval
that defines one moment from another.

I'm filling my pants pocket
with imaginary minutes
dribble clock coinage
down my leg
the incontinent flow of time.

INSTRUCTION

```
IF(FORM,ENERGY)0,1,0

0 VOID

1 MANIFEST

            ENDLESS CHAINS OF ORDER

            CONFORM CHAOS

            ON COMMAND
```

There is a lightness in the telling

THE DOC

In the storm
of my quaking body
standing in front of the crowd,
a clipboard
holds a poem securely,
anchors the forest of words,
stabilizes the dancing letters.

It takes a lot to beat the Doc.
Stiffening joints
search for that subtle adjustment,
playing bocce or ping pong
there is no winning
or losing in this game
just being present
moment by moment.

The temptation
is to imagine what it was like before
or what is coming,
play the comparison game,
regret what is real
in fear
of a future.

There are days
when moving spirit
dragging body
weighs more than
intention can muster,
so lay low
wait for it to go.

I have met resistance
when I want to close the door
grow stiff and hard
deny what is.

If I tried to wish you away
it would only be a dream
built on defiance
forgetting that love promises
to carry me home.

SLOW

There is a species
that
eats slow,
walks slow,
thinks slow
is slow
part of the package
Doc Parkinson left on the porch
plodding
to complete tasks
that once were
automatic.

We hurry to
our place
recognize
the gift of slow
amidst the race
we call normal.

We have
an astronomical duty
to offset
the expanding universe
racing to the frontiers
of oblivion
in a hurry.

I will not join you
embedded
in my dawdling
solar system
one planet short
contentedly waiting
for the next asteroid
to deliver
my notice of extinction.

SURRENDER

If you're going to drink wine
and walk at the same time
best you not have Parkinson's.

We celebrate the choir's performance.
Spontaneous song
rides the evening breeze
as we sip wine
share intimate
and public memories
as the sun goes down
spirits rise.

Gathering my portion
of the pot
I glance down
recognize my wine
on the floor.

My tremor detector
failed to warn me
of the 8.2
shifting Parktonic plates.
I respond with paper towels
grateful it didn't spill
on the carpet.

I think
about how to counter
these mini disasters
but it requires anti-gravity
which is still under development
and St. Andreas
hasn't been responding.

I surrender.
Fill my glass less full,
and carry a big rag.

GOING PUBLIC

The *Present Moment* video
is shown on the "Big Screen"
at Healing Circles Langley.
This screen is small compared to the Clyde Theatre
who is showing *Mad Max* at the same time.

There are some similarities,
post apocalyptic chase stories
mine the apocalypse of Parkinson's
theirs the apocalypse of civilization.
I can only imagine what Max is doing
but this small family
is telling the story
we live.

Questions from the audience
open the door to what lies beneath the surface
and though a tale of struggle
and unwelcome change
there is a lightness in the telling.

Despite the pain and confusion
underneath is joy that grows
from our joining together
to hold this tale
and recognize how much we share
on the road of our trials,
how important this coming together is
in our journey to completion.

ON STAGE

Being a presenter at the HOPE Parkinson's Conference
we have either the best seats in the house
or the worst.
Gazing at the archipelago of round tables
scattered among the sea of witnesses
we are three speakers on the stage
elevated and amplified,
ready for our time in the spotlight.
We sit in the blindness of lighting,
surmise the existence of an audience,
like dark matter we know is there
but cannot quite discern.

As we are introduced my tremors
are working on overtime
even the lucky socks gifted
by my daughter,
cannot overcome.

We show a documentary that depicts
how Parkinson's has entered our familial life.
Sitting on the stage with our infirmities
not only displayed in the flesh
but discussed and explained
in living color
as the moderator asks questions
that drive our story deeper in us
and in our new community.

EMMY
For my daughter Aimie

Imagine an eight minute movie,
that sneaks into a family
as a bit of a therapeutic exercise.
There is no roll-out plan
rather happenstance gives rise
to a core connection that
opens doors around the world.

From Mt. Rainier to Australia
the film found receptive viewers.
Resting on our laurels
we are surprised to learn
the film is nominated
for an Emmy award.

If you're going to imagine
something you might as well
imagine winning.
And if you imagine winning
then you should dress
like a winner.

It's the day of the gala
and time to mount
our rented clothes.
My handful of thumbs
necessitates help
from my son-in-law
to fasten my bow tie.
My 15-year-old grandson
is donning his first tuxedo
and I have the opportunity

to adorn it with a full Windsor knot.
The women have new dresses
that are elegant and meet the grade
except for the shoes
which are fashion-wise but painful.

We gather at the Armory in Fremont
with a full house of attendees.
After an allotted time for milling about,
we settle at tables that face the stage area.
Although we are placed behind a major
support pillar, the plethora of big screen monitors
that fill every nook and cranny insure
that the action on the hidden stage is seen by all.

We eat. We wait.
Through Community Service, Scholarships,
High School, College and University,
Human Interest, Environmental,
Arts/Entertainment, Historic/Culture,
Health/Science – Bingo – there we are,
Present Moment. We are joined by
the Digestive System, Death with Dignity,
the Arctic, Hanford, and Puget Sound.
Formidable foes and ultimately
Hanford takes the gold.

With a grace we have come to expect,
the producer celebrates the nomination
over the triumph which enables us
to appear gracious even as I
secretly desire victory
in my little black heart.

DBS

I reach the milepost
when my medical high priests
propose a change in course.

Outside of my brain
at the receiving dock of treatment,
the payload of little pills
gradually increases
until the driver
takes a dyskinesia break.

There are tests that must be passed:
the "On/Off" test to insure
that the pills can do their job.
The neuro-psych test
to warrant there are cognitive miles
remaining.

We change the focus
from applying change agents
on the outside to modifying
what's going on inside.

Deep Brain Stimulation

Deep: in the heart of the brain.

Brain: the mysterious organ
that is the interface
between mind, body and spirit
with the capacity to retain our history,
imagine our future, inhabit the present.

Stimulation: electric waves
zap the subthalamic nuclei.

Dressed in white surrounded
by instruments and machines,
highly trained surgeons
drill a hole in my head,
insert a wire hooked
to a stimulator implanted
south of my collarbone
that overrides my urge to shake.

Soon I will sit with the
programmer of this probe,
ask my questions
answer his
and make a pact
to find a new homeostasis
together.

RECOVERY

Room 1779, post-op recovery,
17 floors up from the raging storm
that beats against windows
that do not open.
It is the middle of the night.
The demons that occupy
my brain are raising hell.

If they could they might
reek havoc playing chicken
with the mobile nursing stations.
But the licensed drivers
of these couriers of modernity
say nay. They roll their stores
from room to room,
double park in the narrow hallway.

As they pull into my parking space
I am excited for they can tame
my demons with various brews
they carry. Throughout my time
as a registered patient but especially
in the middle of the night,

the appointed nurse enters,
wakes me from my drug induced
slumber and with dedication
bordering on obsession
inquires every two hours:

"Why are you here?"
"What day is it?"
"What is today's date?"
"Hold out your arms, hands up."
"Touch my finger with yours."
"Stick out your tongue."

Until your answers
satisfy the medical tribunal
you will remain in their custody
and care, answering over and over
6 loaded questions.

THE RAMP

Two neighbors and my son
gather in the backyard
to prepare a wheeled entry.
The new path follows the
cement circle avoiding stairs
finds a way into the bedroom.
The sun burns bright and hot
while I watch from my bed
confined and forced into vicarious witness.
It's Thursday. A space between
surgery in Seattle and bed incarceration
at home. I watch the sun fall slowly
to the earth as they move through
the dance of completion
and I prepare to roll home
pushed from behind.

BUTTONS

Perhaps PD wants us to be naked.

My fingers struggle
to force this polished disk
through the narrow slit
to secure two pieces of cloth,
and meet the social requirement
of covering bare skin.

Before Parkinson's Disease
I was almost pill free.
Now pills command
my allegiance to fill
little plastic boxes
that hold my daily allotment.
A tremor replaces
the perfect pressure
that once secured
this transaction.

We labor to separate
what we want
from what we have
the difference left behind.

The road home

ALONE

Dad just turned 95.
An old man
he sits all day
in his blue La-Z-Boy
watching Fox News.

His most recent wife, #3,
has been gone for 45 days
drawn to family and friends
she leaves him at risk
alone.

They met on a tour bus
she being the person up front
with the microphone
he sitting in the front row
flirting.

They married and moved to Florida
on a manmade lake
in a comfortable home
they used for sleeping
and TV.

Wife #3 was clear when she declared
she did not cook although she did thaw
she did not give care
should he grow into an old man
and she reserved the right to visit
friend and family upon her whim.

The extended absence of wife #3
encouraged us to visit and care
but care like the body
is growing and changing
and what was acceptable
in that imagined past
no longer is enough,
harder still to admit
he needs a hand.

We, who crawled from the belly
of wife number one,
are in the middle
between drooping drawers
and what we remember
of better days, between
the natural order of consequence
and control.

We ask, we plead, we implore
we hold out our hand
offering assisted living,
regular meals,
older women.
He declines,
for what he knows
is who he is.
Wary of change,
what he doesn't know
chases him into his hole.

Alone.

GOING FISHING

We are silent as we motor
back to the dock.
There are no fish on our stringer.
We use all our bait
and have nothing to show for it
except a desire to set the hook
and have Mom back.

Trying to rescue
what remains of the family,
Dad rents a cabin
on a lake far away
from the daily challenges
that drive our grief
deeper underground.

The cabin is funky
the boat a bit beat up,
but then so are we.
We motor out
cast our lures
and wait.

I ask about Mom.
An innocent question,
about what she was like
when she was in high school.
I imagine this would open the door,
our loss would be out of the bag
and we would be exposed to the sorrow
that smothers our yearning.

But when I ask my simple question
Dad blows up.
"Why do you want to talk about her?
What's wrong with you?"
He drives us down
deeper into denial
hidden between layers of loss.

My sister and I, orphans,
desperately search
for our missing family
as we fish the small lake
and come back empty handed.

DEAR FATHER

The new blue Oldsmobile convertible
takes us to a small cabin
beside a trout pond somewhere in the woods
to lure our minds back into this world,
away from the empty seat,
and the empty bed
my mother occupied.
But we're not biting,
we have survived the fire and ice
that tries to kill us as we sleep.

Inside my mouth words are dripping
wanting to leave.
I open to let them out
but my lips don't move
only sighs that echo in the hole I carry
that remind me of what I want to forget.

We call out, my sister and I,
but you are too far away to hear.
You put the top down on that new blue convertible
as though the wind will blow away our tears
forever.

THE WALKER

I push the walker
on my shore
imagining you doing
the same across the great divide.
It flows down the hall
secure and stable,
its guarantee
that you shall not fall.
Bent over you bear down
carrying the cargo
of your sweet body
older than my imagination
you lean into the wind
and mirror my own journey
on a far shore
parallel.

ESCAPE

Sitting alone in his chair
Dad waits for wife #3 to return.
We enlist caregiver Judy
to fill in the blanks
like feeding, cleaning,
talking and shopping.

Waiting for the Day of Return
Dad suddenly awakens, sees
his empty home
no bodies, no love
not even consideration.
So what's the point?
Dad decides to file for divorce.

Wife #3 absconded with Dad's Cadillac
for her long sojourn.
Returning with hubris
headlights burning bright
she parks in the garage.
Caregiver Judy parks her car
behind the Caddy
and, just to be on the safe side,
sticks gum on the garage-door sensor.

The doorbell rings.
Wife #3 is served with divorce papers.
This is unexpected and she is not happy
and leaves for her son's in Orlando.

Dad's daughter arrives
packs, gathers Dad and does
the Great Escape to North Carolina.

Dad is transplanted in Walton Woods,
a maximum security
retirement village
with his own room
good food
and ping pong,
although it appears those days are over.
Not enough mustard to coat that dog.

Safe.
Comfortable.
Lonely.

Nearby Daughter
does daily rounds,
reminds Dad to shower,
take his pills,
eat.

This is his last chance
to soften his loneliness
with a friend
or close the door.

FLUFFY HAIR

We inserted a country between us
a culture between us
a paradigm between us.
Until time ran out.

He lives in a brand new upscale
retirement center. His name tag
belies his membership
in the independents
those provided with minimal support:
1 bedroom apartment with outside patio,
a continental breakfast
and off-the-menu dinner
in the dining room
served by young African American men
like ships plying the sea
of a round table archipelago.
Port ladies greet Dad
kiss his forehead,
service the sailor.

In his contract the Keepers pledge
to clean his room once a week.
They provide washer, dryer
and full kitchen unused.
The larder recently filled
with a host of sugary treats.

His daughter and her husband hover over him,
primary caregivers they want to be close,
cooking, cleaning, shopping, socializing.
It is a burden.
For a few days, his son and son's wife join them.

The son's orders this morning:
get him to shower and a change of clothes.
He finds my button
when he states, "I can take care of it.
I get tired of everyone telling me what to do."
My libertarian self rises up
though I know he is not in clear enough space
to chart a course,
he is close to the edge of dignity
given he cannot adequately care
for himself and must be cajoled
into compliance where and when he is able.

But he persists.

As he sits in the same chair 24/7
and doesn't take showers
I remind him
he's at risk of bed sores,
a conclusion no one wants to reach.

He yields. Steps into the shower
washes himself
and emerges ready to meet the family
inspection and accolades
and the bonus social benefit
of fluffy hair,
the gold standard
for proof of shower.

LOVE BURIED

My dad died this morning.
I won't be calling him
and listening to the silence
as we wait for someone,
anyone, to resume
the thread of conversation.

This is an old habit.
We have been avoiding
meaningful conversation
my whole life.
Now I am expected
to say something
significant that conveys
an image, a connection
we never had.

He has shut down
any possibility
of spontaneous comment
by scripting his own memorial.
His funeral arrangements
have been ready and waiting
for forty years,
another closed door.

I'm not upset
that these are fixed
and set in place
for certain
this is his privilege
and it is appropriate.
Rather it was a reflection
of his life
in which there was no invitation
to enter.
We will sing the songs
listed in his program
and read the Bible verses
that haven't changed
for 60 years. We sit
there waiting and wanting
something fresh to join us
that reveals a shared discovery
of love buried in our awkward silence.

MISSING TOOTH

Dad woke up
without a tooth.

In the beginning
teeth leave of their own accord
new teeth from below
push them out
eager to begin
their biting and chewing career.

This one was a volunteer
with no evidence
of subterranean
influence.

Perhaps it is a prank
of a holy patriarch
bored in the middle of another
hot and humid night
with nothing better to do.

Or a parking place
for a passing tooth fairy
on her nightly rounds,
one short
on her missing tooth report.

Or knocked loose
by endorsed violence
after a comment
about the Donald.

Since this happened
in the realm of sleep
sociopathic succubi
must be considered.

Were it hidden
in a more remote
geography of his mouth
it may well have escaped
notice and judgment,
but the missing bite
sits front row center.

Although the dentist can fill the gap,
Dad chooses to leave it
hidden behind the upper lip
until a laugh pops out
and we are taken by surprise
as he smiles through the void.

VETERAN'S DAY

My last visit
was on Veteran's Day.
In the auditorium at the First Baptist Church
they honored Dad's service in WWII.
Army Navy Marines Air Force Coast Guard flags
lay flaccid on their poles
waiting for the breath of patriotism
to unfurl them.
They flank the podium and the big screen
where Dad's story unfolds.

He traveled to the corners of this country
the desert, Bell Labs, California
to gather skills
to fight far away
in some nameless jungle
killing strangers
he never saw.

He recalls foolish decisions,
crossing seas in unguarded ships
put in harms way
over and over
often for no apparent reason
incompetence or insanity
believing we can mobilize and deploy
great hordes of men
to carry out tasks we can never fully endorse
in our soul, the temple of our morality.

Dad battled on the table of ping pong
and won a lifetime of socks
risking the authentic airman's leather jacket
he borrowed in his hubris.

Death at the door
leaves empty handed
allows him to wear his hard earned booty
asking only later "why not me?"
It was not his time,
for it is written that he should tell his story
at the First Baptist Church and sing the praises
of those of the nation state
who did not return
and salute the flags of all those agents
sent to carry out the plans of leaders
sitting in their safe and comfortable lives
so far from the mud and sweat.

There are not many WWII vets left.
You need to be quite old to qualify
and willing to tell the same stories
over and over.
They love to tell these stories
to give life meaning
and to forget
that deep inside they weep
alone
in the knowledge of their complicity
in the grief of their great loss.

To soak our roots

BOER ON A BRASS BED

Boer on a brass bed,
Saturday throne
the *Gros Baas* holds court
in the Kalahari kingdom.

At the foot of the bed stands
Jan Witboy
John Whiteboy
the Griqua brother
of head man Cornelius
who stands beside the bed
on the right hand of God.

They all stand attentive.
The Great Man will speak
and tell them what to do.
This is the business
their bloodlines
have carried
to this day.

Glen Ruby,
precious Kalahari farm,
you are the heart
of this harsh land.
We come to soak our roots
in this dry land.

The sun turns red
and oddly cool
before it falls
behind the distant hills.
It seems to take longer to go
than it did to arrive,
reluctant, like us,
to leave this world
and the old brass bed.

CRACK IN THE CORE
For Frikki Horne

Branches that once sheltered this place
lie rotting
and the merciless sun penetrates
a place long reserved.
The posts appear whole at first glance,
the plaster only broken in places.
A closer look reveals cracks in the core.

Oh dear Frikki, our Afrikaans *boer*
who sits on the grand porch
with a few companions
in the waning light.
You speak of glory and children
when these mountains
shouted their wisdom
and you could hear.
Now you wait for the voice to return
to lead you forward
in this confusing world.

Now the brass bed is your throne,
a circle of lives with eager faces
gather around you.
You declare, direct and give order
to a world in the corner
of an almost forgotten shadow,
far from the manic rush to change.
The chain dissolves as links rust
in the spreading river of uncertainty and fear
and the vision is not as clear or stalwart
as the past seems to promise.

You are still the great master of Suid Afrika,
the *gross baas*, in whose shadow these men of the field
find a part of their light,

dimmed by change
and a flame fallen from its old roar
to a flicker waiting
for the last spark to flee.

At times you are like the *swarthaak* in late winter,
on the brink of bursting
into delicate and heady bridal veils
that, in innocence, surround and perfume
sharp hooks of bitterness and disappointment.
A soul embedded here
seeks the solace and comfort
that sharp memory brings to life.

Old companions cloud the day.
They rise early and do not depart readily
or release their grip on your spirit
which soars at the slightest provocation
and so quickly falls back
into a place made to hide the demons
that hook and stick
and will not release you.

I stand and watch
and want another world
to come and replace this one
that imprisons us together in this moment,
to return to another world
in another place
where your armor was thinner
and your views softer.

The wounds are open, you cannot staunch
the flow, so turn
your back and be proud.
Walk down that final hallway
ever so lightly into the shadow
of your last dark moon.

KALAHARI

I walk along the dry riverbed
that begs the dark moon
to raise the waters
to relieve its great thirst,
prayers pass through my feet.

The borehole brings water
buried long ago
it flows now on command
to this lonely farm
wetting our dry lives.

I sleep on the porch
under a broken roof,
earthen post sentinels
around me.
The mountains, vague shadows,
beckon me
to climb their boulder-strewn flanks
and return to a twig fire
under a night full of stars.

Scattered across the mountain's side
a family of baboons eat their way to the top,
lifting stones in search of grubs
to ease their urgent hunger.
Sitting on a rise, *Brandwag*, the Watcher,
sees danger before it is a threat-
holding the edge of each moment
he creates and enforces
the boundary of their limits.

Small monkeys play and bound easily
over the rocky hillside
as old ones dawdle,
he encourages them
to keep moving, to keep close
to his circle of safety.

I follow their simian path,
place my footprint next to theirs.
I, too, look under stones
for a deeper place inside
the part of me that meets the sun,
the wind and the infrequent rain.

Mandela sits on his rise
intent to guide his children home.
If only it were as simple
to guide the heart of this ancient land
as it is for these monkeys
to climb this rocky hillside,
his children's hunger more demanding,
the grubs more difficult to find.

There is a voice that whispers,
tells me tales of journeys over this mountain
that leads me to a circle on top
where I rest and watch and listen
to the silence that sits so deep in this place
and now in me.

MANGAUNG

I see you
cautious and suspicious
wondering what these strange white folks
are doing in your South African township of Mangaung.
We rubbed against the space between us
wanting and afraid
reaching and withdrawing
we strive
to bring their dreams to life.

Angry stones tried to kill us
when they stole your hero.
Hooligans stabbed us and
took what they wanted
in the shadow of shelter,
forfeiting the dream.

We left hopeful
that you would see your world
through the lens of tomorrow
as we see it.
But hungry babies
do not readily mix
with money in the bank
waiting for some future day's needs
as we see it
in our tiny mind's eye.

As though the long years
pleasing the *baas*
were someone else's dream,
liberation only changes the color of privilege.
When we learn you have taken what was there
rather than wait for what we hoped you would imagine,
we move farther away
and try to forget.

We deposit a piece of ourselves in their choices
but cannot redeem it in their action
cannot redeem ourselves except in judgement
which we cannot pass on one life so precious
so close
so far away.

REQUIEM
For Silja Horne

A bleating chorus
three sheep huddle
in the back of a pickup,
on their way to a funeral
in a mud hut.

In front of the hut a tent
covers twelve empty chairs,
awaiting their assigned mourners.

A callused black hand
holds my callused white one
leads me as a cherished auntie
into the sanctum, to the body
on its wooden bed.

Two candles
in front of the coffin
remind me of what I have lost
on the dusty road here.

The sheep are removed.
Their warm blood
slakes the deep thirst
this dry land harbors.

It is so simple
in the center of silence
present and apart
from what we think.

A baby wails in the dark
mudroom hole. We join her
as we cry for loved ones
and dead ones,
stones in our stomach.

Book design: Roosje Wiedijk
Cover Photo: Theresa Durant Photography
Author Photo: Noah Dassel

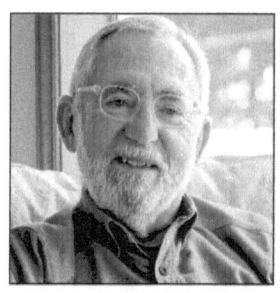

GARY VALLAT
Biography

With roots in the Midwest and mathematics, and a long passage in the Skagit Valley centered on career and family, Gary Vallat is currently living on the lovely south shore of community-minded Whidbey Island – with his wife Rubye, and their children and grandchildren only a ferry ride away, across the Puget Sound.

In 2016, his daughter Aimie directed *Present Moment*, a film documenting Parkinson's influence on their family through the lens of Gary's philosophical approach to life and healing, including his poetry. The film inspired publishing this collection of writing. Here, Gary studies and reveals a personal deepening of insight while honing the relationships between experience, ideas, and the nature of words.

www.ingramcontent.com/pod-product-compliance
Lightning Source LLC
Chambersburg PA
CBHW030651220526
45463CB00005B/1734